INGRES

Drawings from the Musée Ingres at Montauban
and other collections

Arts Council
OF GREAT BRITAIN

Acknowledgment

© Arts Council of Great Britain
M Pierre Barousse, Dr Michael Kauffmann

Exhibition Officer: Janet Holt
Assistant: Jacqueline Eland

Catalogue designed by Charlton/Szyszkowski
Printed by Shenval Press, Harlow, UK

ISBN 0 7287 0204 5

The Arts Council welcomed the proposal from the French Embassy in London that a selection of drawings by Ingres from the collection of the Musée Ingres on Montauban should be shown in several galleries in England under the auspices of the Arts Council. The exhibition has been prepared in collaboration with the Victoria and Albert Museum, where it will be shown first. The selection of drawings was made by Dr Michael Kauffmann, Keeper of Prints and Drawings at the Victoria and Albert Museum and Monsieur Pierre Barousse, Conservateur of the Musée Ingres. Monsieur Barousse has also written an introductory essay for the catalogue which has been prepared by Dr Kauffmann and Janet Holt.

The exhibition is being shown under the patronage of the Association Française d'Action Artistique. We would also like to thank Monsieur Hubert Landais, Directeur des Musées de France, and the Mayor of Montauban for supporting this project. We have again benefitted from the close collaboration of Monsieur Yves Mabin, Cultural Attaché at the French Embassy.

It was thought particularly appropriate to supplement the exhibition with six excellent examples of Ingres' portrait drawings of English sitters which would be of special interest to the English public. We would like to thank the British Museum, the Victoria and Albert Museum, the Fitzwilliam Museum, the Rijksmuseum Amsterdam, Mr R. E. J. Compton, and Mrs Marianne Feilchenfeldt for generously lending these exceptional works.

Joanna Drew
Director of Art

Contents

The drawings of Ingres or the poetry in his work

'If I had to put a sign above my door,' said Ingres, 'it would read: SCHOOL OF DRAWING and I am sure I would produce painters'. This saying by the author of the *Grande Odalisque*, has often been quoted. According to his biographer Delaborde, he held that 'When you are master of your craft and have learned to imitate Nature, the most arduous task is to think the whole of your picture, to know it, as it were, by heart, in order to execute it afterwards with warmth and as an entirety'. Ingres' drawings are so informative and captivating that we are able to follow, from sheet to sheet, the unheard and unseen process of creation, its approach, its gropings, its variants.

The first idea for the picture comes suddenly to the mind of the artist in the excitement of a revelation or an acknowledgment of fact. It first takes the shape of a rough pencil or pen-drawing, most often rapid and almost shorthand, so that nothing can escape from an inspiration as uneasy as it is sudden. These sketches, sometimes revealing a beautiful flowing line, are too often misunderstood. Being close to unconscious inspiration they show us an irrational side of Ingres, so much so that many an idea, hurriedly jotted down, would not outlive this stage, as for instance his furious *Triumph of Mediocrity* which he had thought up after the failure of his *Martyrdom of St Symphorian*. It is said that the whole composition and the central group of the *Apotheosis of Homer* came to him within an hour of the commission. For the *Golden Age* or *Jesus among the Doctors*, it was from a crowd of figures and groups scattered across the paper that the final composition slowly emerged.

The initial inspiration, is followed by a slower stage, more ponderous and certainly more thankless: the documentation. Ingres never forgot he had studied with David. But in his case his concern for archeological truth and historical accuracy was so compelling that time and again he meticulously copied or traced engravings from books of antiquities, like the *Iconography* of Visconti. This concern also prompted him to study very diverse styles, that of the drawings on Greek vases, of the Italian primitive painters, of the Flemish painters or of Poussin, whose resolution – which Ingres could but endorse – was to paint 'an order in which every object is maintained in its essence'. One must particularly make a mention of Raphael, whom he imitated and for whom he developed a true devotion, which worried him, lest this had led him on to a path not entirely his own. The painter of the Stanze, Ingres used to say 'carried all nature in his head', he was 'like a second creator': Ingres felt incompetent besides him.

So scrupulous a procedure often brings incongruities and anachronisms, and sometimes it must be admitted, stolen aspect to a picture, resulting from the lack of imagination of the painter, and yet justified by the strongly individual character of his painting, which makes these 'borrowings' his very own. He was to remain faithful to this method all his life. Even a few days before his death at nearly ninety years of age, he copied in pencil a portrait by Holbein. Someone, seeing him very tired, asked why he was taking so much trouble. 'I am learning', replied the master.

Yet all this slow research work, in the long run, hindered Ingres as much as it helped him. There is surely a retreat from the first breakthrough made in his sketches as though he was wary of rediscovering the initial inspiration. Perhaps the principal merit of such excessive research is finally that of allowing his inspiration to ripen secretly. It would seem that the documentation stage was nothing more than a long and dogged propitiatory act.

Ingres then commissioned a professional model or a student to take up the pose of the figure which he had scrupulously copied. He usually drew the model in pencil, first nude then clothed. Head, hands and feet are studied separately as required. To capture movement, he multiplied arms and legs in the same drawing, as he did for the mother in the *Martyrdom of St Symphorian*. Paradoxically, in his studies the painter tried to be all the more aware of what in reality had moved him unconsciously. 'As for this arm', said Ingres when he was working on the figure of Antiochus for *Antiochus and Stratonice*, 'I am sure that is better now than it has ever been. I have definite proof of this, since I have drawn all the others.' Nothing less than mathematical proof, obviously decided by highly subjective *a priori* reasoning. 'Ingres', said Picasso on this subject, 'drew like Ingres and not like the things he drew.'

The evolution of the figure of Angelica, in *Angelica saved by Ruggiero*, towards the sinuous S line which is the very seal of feminity for Ingres, is in this respect, the sign of the constant but unconscious purpose of its author. He inflects the line according to his inner need: in the general sketches, the drawings and also the studies in paint, the head of the figure, at first turned to the right and then to the left, almost inevitably topples backwards, the hands held behind the back and then brought up to head level. All this in order to accentuate the S shape. The result is the famous 'cou goitreux' (goitrous neck) regardless of anatomical correctness, which disconcerted the critics of the time and inspired a nineteenth century medical publication, strangely entitled: *The thyroid gland in the work of M. Ingres*. A contemporary painter, de Waroquier, understandably saw a 'third breast' in the generous bosom of Angelica. In fact she displays all the painter's questioning when faced with the enigma of feminity imagined as both fascinating and frightening – illustration of the Serpent promising the forbidden fruit.
It is in fact for this obscure and obstinate reason that, in general, the drawings of female nudes, however simplified they might be, assert the complexity of their line, and their triumphant sensuality. The use of tracing to which Ingres resorted plays a further part in paring down his drawing, gradually freeing it from this 'inner form' which he nevertheless claims. 'Drawing', he said, 'is not just reproducing contours, it is not just the line; drawing is also the expression, the inner form, the composition, the modelling. See what is left after that. Drawing is seven eighths of what makes up painting.' 'Drawing includes everything except colour.' It is also an ethic, almost a principle; it is 'the integrity of art'.

Ingres' ideal is 'history painting' free of anecdotal accident but outlining nevertheless the individual character, expressed, according to him, by drawing. Once the choice of attitude and gesture has been made, the drawn figure is transferred as it is on to the canvas, and juxtaposed to its neighbour with painstaking care. This task, which sometimes borders on obsession, generally ruins the fullness and movement of the canvas; the exactness of detail harms the form and the true sense of the whole. In spite of peculiar beauties, Ingres' large compositions appear, says Naef, 'like the catalogue or the index of an admirable world of preparatory drawings, executed from nature'. Furthermore Ingres quite often uses naturlistic colours, which are not in keeping with the sharpness of his line. From this results an impression of artificiality and a coldness often apparent in the large surfaces, but from which certain really 'inspired' figures escape as for example Angelica. And yet Ingres was to persist in disowning his real talents, and stubbornly pursue till the end his ambition to be a history painter, the academic genre par excellence of the nineteenth century.

The portraits painted of the aristocracy or the bourgeoisie were likewise the occasion for pencil studies, of strong line and lively flexibility. These portraits, unhampered by any anxiety over composition, are distinguished by a particular psychological realism. The portraits of women show in addition a heavy sensual aura (Mme de Senonnes) or an intensely poetic light (Mme d'Haussonville). Generally, in the most successful pictures his slavish toil, particularly in the drawing, does not get the better of what the painter at all costs wants to tell us. His drawing might be considered the poetry of Ingres' work, whereas his painting, at least in his claims to epic historical or religious vision, has some characteristics of the bourgeois novel of the time: Ingres has been mentioned in connection with the Flaubert of *Madame Bovary*.

The drawn portraits, executed by the artist to earn a living during his first stay in Rome, and his views of Rome, also in pencil, are finished works, which could also be said of some of his figure or drapery studies. The portraits, delicately drawn in pencil, make up a real gallery of the people in Ingres' life, like Mme de Lauréal or Madeleine Chapelle, the painter's first wife, or famous people like Caroline Murat. The sharpest realism culminates here in pure 'abstraction'. It brings to mind Ingres' advice to his students: 'Faîtes-vous des yeux' (create your own eyes). He made pen sketches from life of intimate scenes, now touching, now enjoyable.

His views of Rome, in pencil or pen, sometimes with sepia wash, mostly strangely devoid of any human element, foreshadow paintings by de Chirico. These engaging views which amount to no more than studies of monuments or landscapes, express the feeling experienced by their author, of being at the centre of the world – a notion of the Renaissance and of a classical conception of art, from which he is separated by many features in spite of himself and almost without his knowledge. However, it is principally in Rome, between the age of 26 and 40 that Ingres formulated his art in its

The case of Ingres is certainly disturbing when one realized in how many ways a variety of artists claim him as their master, from the most plainly conventional of the nineteenth century such as Cabanel or Bouguereau, to the most revolutionary of our century from Matisse to Picasso. A classicist? Above all, he was moved by the impulse to penetrate the secret of natural beauty and to reinterpret it through its own means; an attitude fundamentally different to that of David. It is assuredly not without reason that the critic, Théophile Silvestre described him in his review of 1856 as a 'Chinaman lost in the streets of Athens'. Ingres was attracted by nature to the *fêtes galantes* and the languorous forms displayed in the charm and virtuosity of eighteenth century paintings but he exercised a control over himself and remained strict, exacting and *tense* in the manner of Masaccio or Masolino, a panel by whom was included in his personal collection. From the contrast of these two tendencies, which was sometimes trying and fierce, there results a truly personal and unique art admired as much by the Cubists for its plastic autonomy, as by the Surrealists for its visionary qualities.

But Cubism and Surrealism already belong to the past. At a time when artistic production wishfully seeks the ephemeral, the cold or a conceptual trick, or yet a disintegrated photographic picture, all buried in obscure talk, Ingres contributes a lesson in 'integrity' an example of the effort and the asceticism needed to elevate and purify: two words written with hesitation today. And his teaching will still be relevant when art is no longer considered an end and an aim in itself, when it stops being saved by purely artistic or even ideological means, when it is freed from its individualistic impasse, when, in a word, individual conscience is again in touch with universal conscience.

The Musée Ingres of Montauban is happy to contribute to the present exhibition thanks to the very pertinent choice made by Dr Kauffmann, Keeper of Prints Drawings and Paintings at the Victoria and Albert Museum, from its collection of some 4000 drawings by the master. It will help to make better known an artist sometimes described as 'academic' but in truth one of the most complex personalities, as difficult for us to define as it was for him to live.

Pierre Barousse, Keeper of the Musée Ingres

Chronology

Montaubon	1780	29 August. Birth of Jean-Auguste Dominique Ingres
	1791-97	Pupil of Joseph Roques
Toulouse	1797-1806	Pupil of David
Paris	1801	Won Prix de Rome
	1804	*Portrait of Napoleon as First Consul*
	1805	Portraits of M., Mme and Mlle Riviere
	1806	*Portrait of Napoleon enthroned*
	1806-20	
Rome	1807	*Portrait of Granet*
	1808	*Bather of Valpinçon, Oedipus and the Spinx*
	1811	*Jupiter and Thetis*
	1813	*Dream of Ossian*
		Married Madeleine Chapelle
	1814	*'La grande Odalisque'*
	1820-24	
Florence	1824	*The vow of Louis XIII*
	1824-35	Professor of the Ecole des Beaux Arts
Paris	1827	*Apotheosis of Homer*
	1832	*Portrait of M. Bertin*
	1834	*The Martyrdom of St Symphorian*
	1835-41	Director of the French Academy in Rome
Rome	1839	*Odalisque with a slave*
	1840	*Antiochus and Stratonice*
	1841-67	Created a Senator in 1862
Paris	1843	Began *The Golden Age* at Château Dampierre (never finished)
	1845	Portrait of Mme d'Haussonville
	1849	Death of Madeleine Chapelle, his first wife
	1851	*Portrait of Mme Moitessier*
	1852	Married 2nd wife Delphine Ramel
	1856	*Portrait of Mme Moitessier*
	1862	*Jesus among the doctors*
	1862	*The Turkish Bath*
	1867	14 January. Death of Ingres at his home on the Quai Voltaire.

Catalogue Note

The drawings exhibited are from the Musée Ingres at Montauban unless otherwise stated. Only those of English and Scottish sitters, which were felt to be of particular interest to visitors to the exhibition, have been borrowed from other sources.

All works are on paper, and dimensions are given in millimetres, height preceding width.

The literature on Ingres is extensive and all the drawings included in this exhibition have been published. Following the Musée Ingres inventory number, references have been given to the most important publications which give full details about provenance, literature and exhibitions.

The following abbreviations have been used in the catalogue:

*	Only available for the exhibition at the Victoria and Albert Museum
M.	Jules Momméja, *Collection Ingres au Musée de Montauban* in *Inventaire général des richesse d'art de la France, monuments provenance civils*, Vol. VII, Paris 1905
London	*Ingres, Drawings from the Musée Ingres, Montauban*, London, Manchester, Leeds, The Arts Council, 1957
Naef, *Rome*	Hans Naef, *Rome vue par Ingres*, Lausanne, 1960
Naef, *Bildnis*	Hans Naef, *Die Bildniszeichnungen von J.-A.-D. Ingres*, Bern, vols. I & IV, 1977; vol. II, 1978
Paris	*Ingres Exhibition* at Petit Palais, Paris, 1967
W.	Georges Wildenstein, *The Paintings of J.A.D. Ingres* 25 etc. 1956
Ford	Brinsley Ford, 'Ingres' Portrait Drawings of English People at Rome 1806-20', *Burlington Magazine*, LXXXV, 1939, pp. 3-13
Ternois	Daniel Ternois, *Les Dessins d'Ingres au Musée de Montauban: Les Portraits* (Inventaire Général des Dessins des Musées de Province, III), 1959.

Landscapes

1 Villa Medici 1807
Pencil and sepia wash: 288 x 231
Inscribed: *Villa Medici*; *3 du clair*; *Ingres d. 187*
(without doubt for 1807) *Rom*
867.4414; London, No. 5; Naef, *Rome*,
No. 4

The Villa Medici was bought by Napoleon
in 1801, and the French Academy installed
there in 1803.

Ingres was awarded the first prize in the
Prix de Rome in September 1801. It was not
until October 1806 that he received the prize
money, and was able to go to Rome. He was
warmly received by Suvée, the Director of
the French Academy, and given the use of a
studio in the pavilion of S. Gaetano in the
grounds of the Villa Medici on the Pincio. On
completion of his studentship four years
later he took a studio at 40 Via Gregoriana
instead of returning to Paris.

Ingres drew this view of the Villa Medici
from the south east from his room in the
pavilion of S. Gaetano. It is possible that this
drawing is mentioned in a letter of December
25th 1806 written to his fiancée
Julie Forestier.

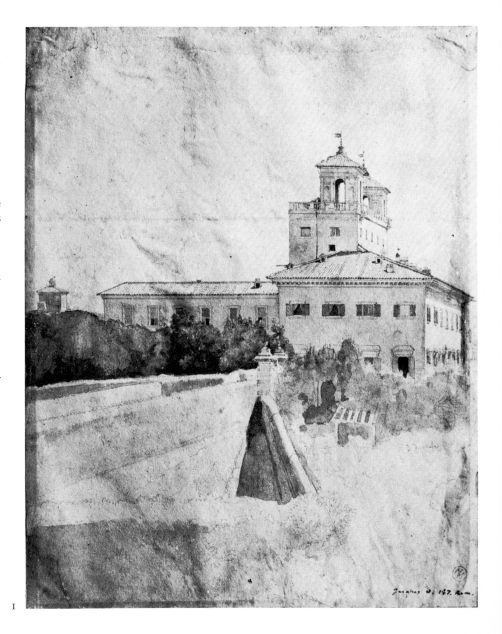

1

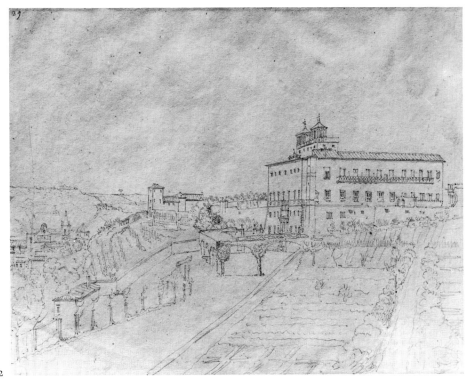

2

2 The Villa Medici 1808-10
Pencil: 183 x 235
Numbered, top left: *29*
867.4437; Naef, *Rome*, No. 25; Paris, No. 42.

To the left in the background, the Porta del Popolo, with the tower and cupola of the church of S. Maria del Popolo. In the centre, the pavilion of S. Gaetano, the main building of the Villa Medici showing the façade facing the town.

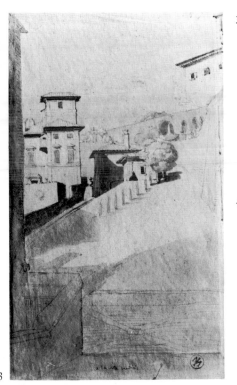

3

3 Salita San Sebastianello
Pencil and sepia wash: 199 x 122
Inscribed: *a la villa medicis*
867.4436; Naef, *Rome*, No. 29

To the upper right, a part of the façade of the Villa Medici.

4 Interior
Pencil and watercolour: 101 x 79
Upper edge, centre, colour notes.
867.4450; Naef, *Rome*, No. 38; Paris, No. 32

It is assumed that this is a drawing of one of the rooms in which Ingres lived in Rome after leaving the Villa Medici in 1810 and before his departure for Florence in 1820. Where Ingres lived between 1810 until 1814 is not known, but from 1815 until 1818 he lived at No. 34 Via Gregoriana, and in late 1820 he moved to No. 20.

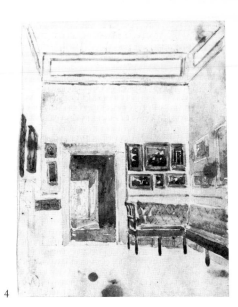

4

5 View from the Villa Medici in the direction of St Peters
Pencil and ink wash: 103 x 181
867.4441; Naef, *Rome*, No. 27

To the left, the Castel Sant' Angelo, which was originally the Mausoleum of Hadrian and subsequently a fortress. In the distance, emerging from the mist, the dome of St Peters, and to the right, the fountain in front of the Villa Medici.

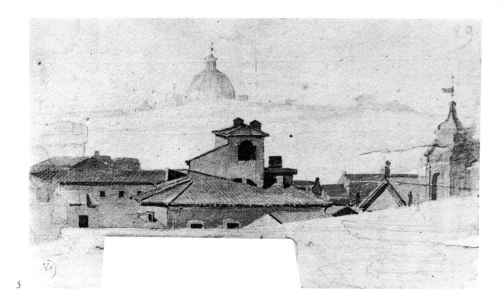

5

6 The square in front of the church of Trinità dei Monti
Pencil and sepia wash: 109 x 138
867.4398; Naef, *Rome*, No. 33

A view of the square at the top of the Spanish Steps. In the centre of the square is an obelisk, a Roman imitation of the Egyptian imperial type found in the Garden of Salust. It was set in the square in 1788. To the right, dominating the square is the church of Trinità dei Monti begun in 1502 by Louis XII of France. In the centre is a view of the Villa Medici. To the left the pavilion of S. Gaetano.

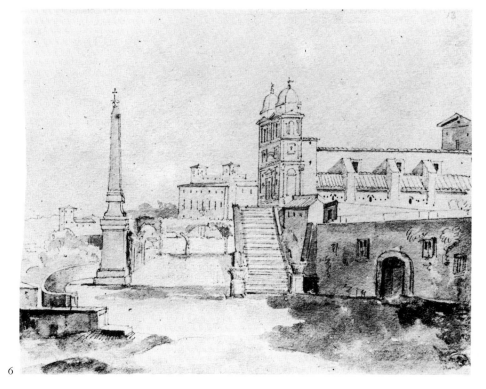

6

8 A view with S. Maria Maggiore
Pencil and sepia wash: 170 x 243
867.4372; Naef, *Rome*, No. 52; Paris, No. 49

This view is drawn from the Esquiline hill. To the left is one of the two cupolas and the tower of S. Maria Maggiore; in the middle, rising above the houses in the square before S. Maria Maggiore, the column of the Virgin.

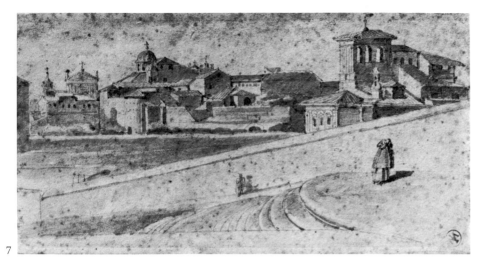

7 **A view taken from S. Maria Maggiore in the direction of S. Bernardo**
Pencil and ink wash: 107 x 211
867.4375; Naef, *Rome*, No. 49

In the foreground the steps down from the east end of S. Maria Maggiore; to the left in the middle distance the tower and façade of S. Susanna, and to the right the dome of S. Bernardo.

7

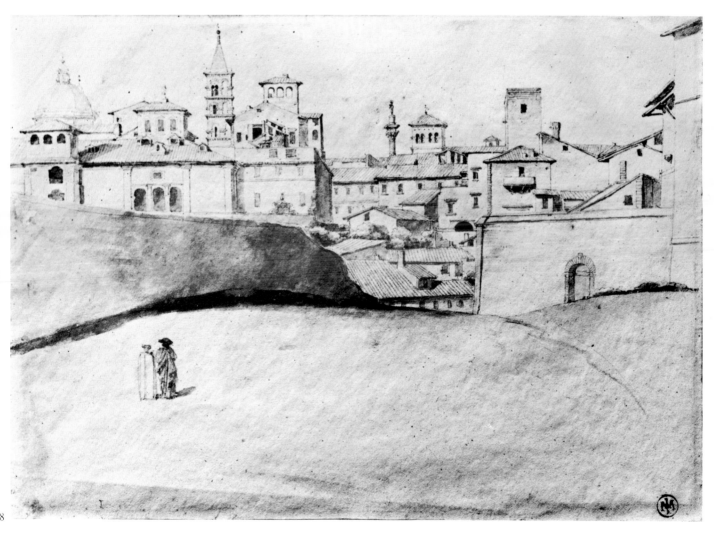

8

9 View of the entrance of the convent of the Santi Quattro Coronati
Pencil: 176 x 228
Inscribed, lower left: *Vue de l'entrée de/S Quattro*
867.4337; Naef, *Rome*, No. 85

The present building dates from 1111. The dedication recalls the tradition of five sculptors who refused to make a statue of Aesculapius and of four soldiers, the Coronati, who refused to worship it. The church is venerated by sculptors and marble masons.

10 The churches of Santa Sabina and Sant' Alessio
Pencil: 172 x 236
Inscribed, lower left: *Vue de S. Sabine au mont avantin*
867.4391; Naef, *Rome*, No. 96

To the right the entrance portico of Santa Sabina, built on the Aventine Hill. This church is supposedly built on the site of the house of the sainted Roman matron Sabina. In the background is the tower of Sant' Alessio.

11 Panoramic view of Rome
Pencil and sepia wash: 130 x 493
867.4439; Naef, *Rome*, No. 32; Paris, No. 30

Ingres drew this view from the windows of his room in the pavilion of S. Gaetano. From left, to right one sees the palace of the Villa Medici, the Torre de Malte, the towers of S. Trinità dei Monti, the obelisk, the Quirinal and the Torre delle Milizie.

12 A view of the Vatican from the Arco Oscuro
Pencil: 182 x 236
Inscribed: *Vue du Vatican*; *37*
867.4400; Naef, *Rome*, No. 110; Paris, No. 48

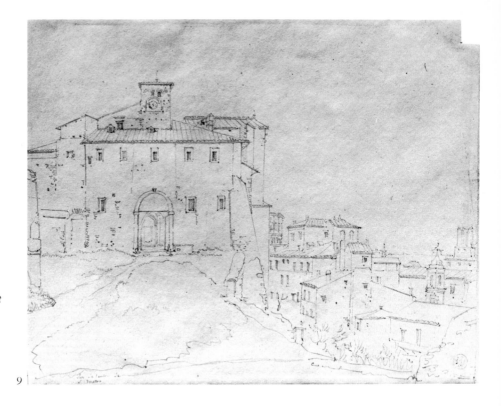

9

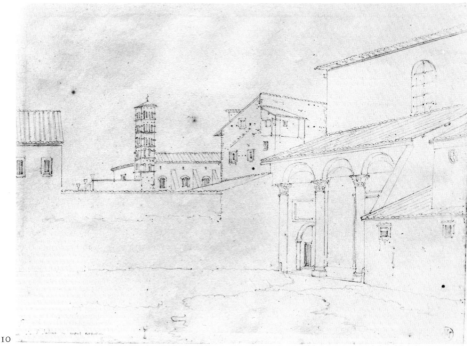

10

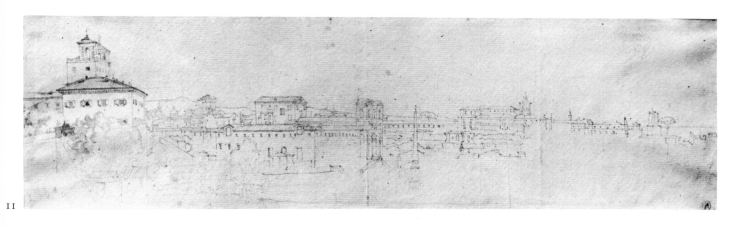

11

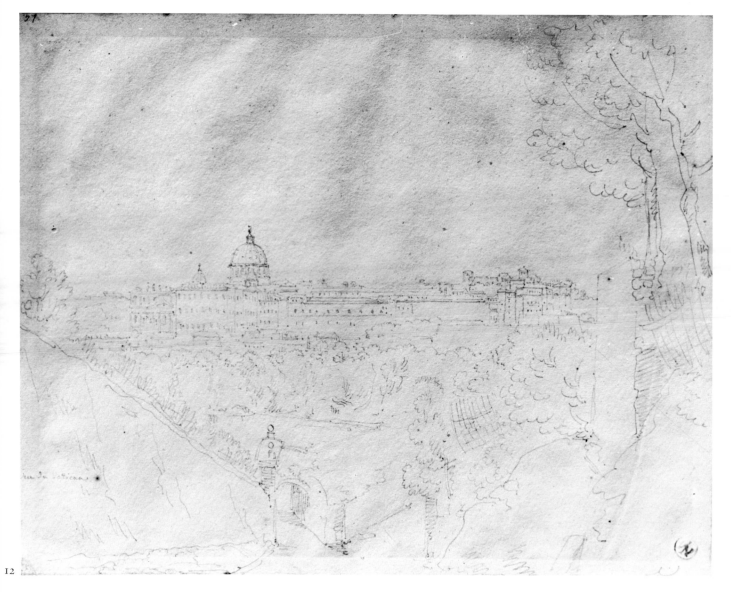

12

13 Castel Gandolfo and Lake Albano
Pencil and watercolour: 148 x 266
867.4269; Naef, *Rome*, No. 139

Castel Gandolfo is built on the lip of the
volcanic crater, which forms Lake Albano.
The Papal Summer Palace was begun by the
architect Carlo Maderno in 1624,
commissioned by Pope Urban VIII and
enlarged by succeeding popes.

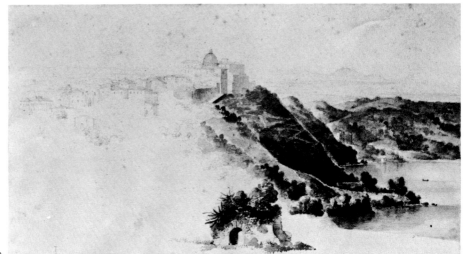

13

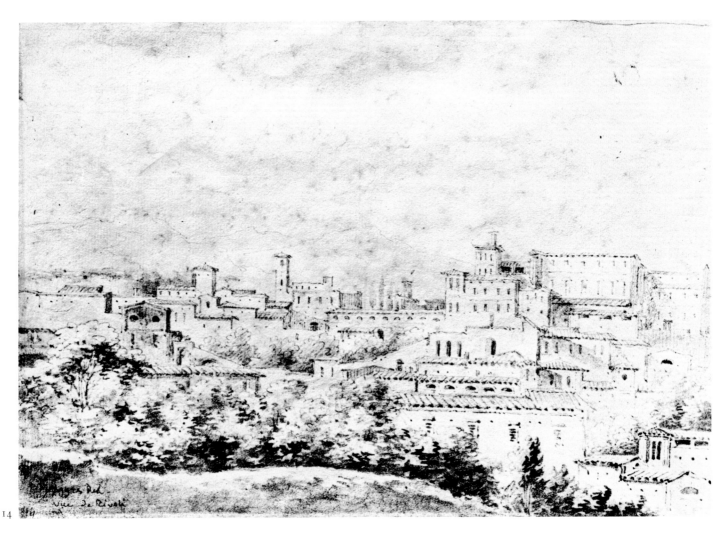

14

15 View of houses at Tivoli
Pencil and watercolour: 94 x 163
867.4489; Naef, *Rome*, No. 130

These houses still exist and are found on the
Via del Colle, Tivoli.

14 View of Tivoli 1814
Pencil and sepia wash: 187 x 268
Inscribed: *J. Ingres Del -/ vue de Tivoli*; *19* (or
39); *1814* (perhaps in Ingres' hand).
867.4453; London, No. 43; Naef, *Rome*, No.
128, Paris, No. 74.

Tivoli is about twenty miles outside Rome
and situated on the lower slopes of the
Sabine Hills. It is renowned for its Roman and
medieval monuments.

16 Vesuvius
Pencil and sepia wash: 145 x 357
867.4303

A view of the famous volcano, Vesuvius,
near Naples.

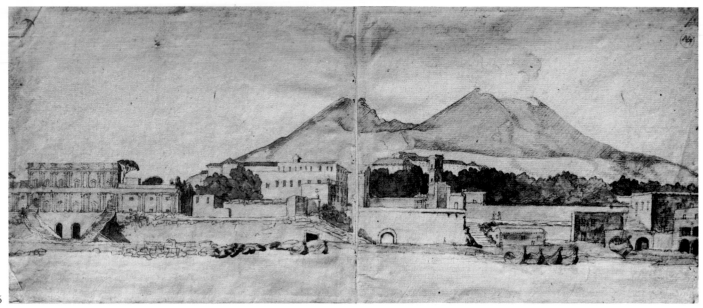

Early Portraits
1792-1822

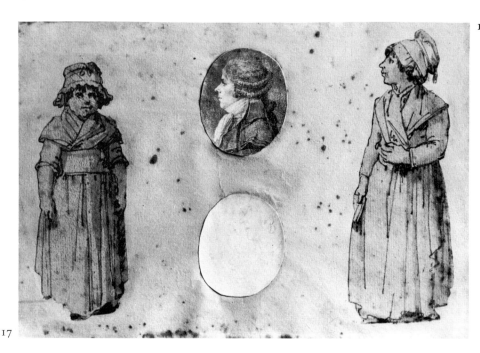

17

17 Ingres' Family *c.* 1792-94
Collage of four small portraits of his parents
and two sisters: 171 x 252
Jean Marie Joseph Ingres (1755-1814)
painter and decorator. Pencil on vellum, oval
Anne Ingres, neé Moulet (1758-1817) with
two daughters Augustine and Marie. Pencil
on vellum oval
Jeanne-Augustine (b. 1787) the painter's sister.
Pen and sepia wash, cut along outline
Jeanne-Anne-Marie (b. 1790) the painter's
sister. Pen and sepia wash, cut along outline
867.275; M. 68; Ternois, No. 78-81; Naef,
Bildnis, No. 3, 5, 7, 8

These four drawings were formerly thought
to have been made at the same time, in about
1787 just before Ingres left Montauban to
study in Toulouse. However, they are very
different in style and technique and Hans Naef
has suggested the following dates: the
father, *c.* 1792 on grounds of costume and
comparison with similar profile portraits
drawn by the precocious artist at the age of
12; the mother *c.* 1793 on the basis of the
girls' dates of birth in 1787 and 1790; and the
two daughters, *c.* 1794 which would show
them at the ages of 7 and 4 respectively.
Joseph and Anne Ingres had seven children,
the oldest being the painter. Apart from the
two daughters shown here, two children
died in infancy and twin sons were born in
1799, after these drawings were made.

18 **The Forestier Family** 1806

Pencil: 241 x 325
867.243 (Lapauze gift); Ternois No. 54;
Naef, *Bildnis*, No. 34

Julie Forestier, Ingres' fiancée in 1806, stands
in the centre, her father, a lawyer, and
mother are on her right and left and her
mother's brother and the maid on the far left.
Julie (b. 1787) was a painter and amateur
pianist. The couple became engaged in or
before 1806, but Ingres broke off the
engagement during his first year in Rome in
1807. Julie never married and recounted the
story in an unpublished novel *Emma ou la
fiancée*. This is one of the very few group
portraits by Ingres. There are three
drawings of the composition; the best, dated

1806, is in the Louvre; the Montauban
version is the second; the third is a tracing,
apparently also by Ingres, in the Fogg Art
Museum, Cambridge, Mass.

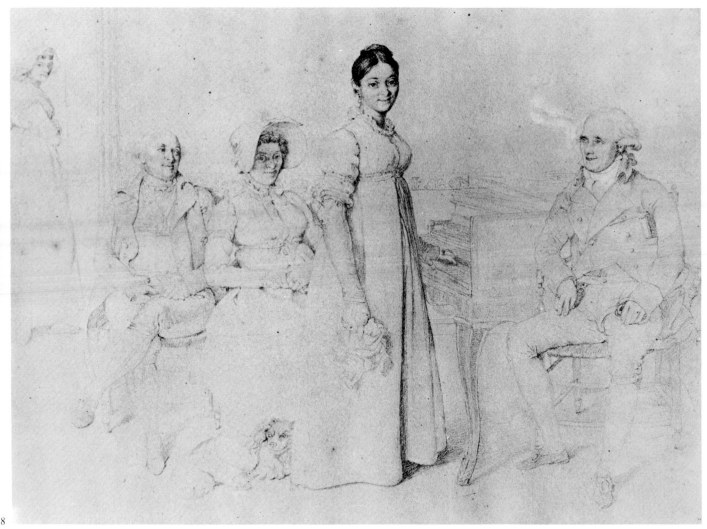

18

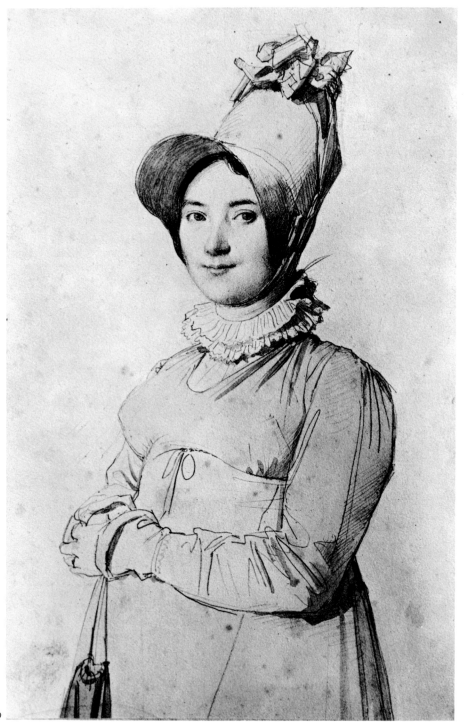

19

19 Madame Ingres, née Madeleine
Chapelle (1782-1849) 1813-14
Pencil and water-colour: 215 x 148
867.277; M. 70; Ternois, No. 83, Naef,
Bildnis, No. 97.

Madeleine Chapelle, born at Chalons-sur-
Marne in 1782, was introduced to Ingres by
his friend Lauréal who had married her
cousin. Without having met her, Ingres
wrote to her in Guéret, she came to Rome in
September 1813 and they were married on
4 December.

For all the erotic obsessions which appear
in Ingres' work, it was, by all accounts, a
most happy marriage and Ingres was
heartbroken when Madeleine died in 1849.
This portrait is the earliest of many he made
of his wife; it is usually dated *c.* 1813-14 soon
after her arrival in Rome. For a later
portrait of her, see No. 32.

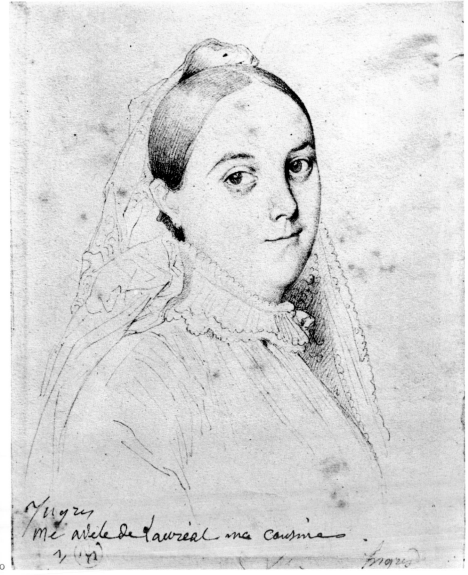

20

21

20 Mme de Lauréal, née Adélaide Nicaise-Lacroix (b. 1782) *c.* 1813
Pencil: 148 x 117
Signed, left: *Ingres*; inscribed: *Mme Adele de Lauréal ma cousine*
867.291; M. 3802; Ternois, No. 95; Naef, *Bildnis*, No. 103

J-F Stanislas Maizony de Lauréal, a French magistrate who held office in Rome during the Napoleonic period, and his wife Adele, were among the principal friends and patrons of Ingres in Rome from 1810. Their Salon was frequented by several French artists including Granet and David D'Angers, but their friendship with Ingres was of a more personal nature, and it was Mme de Lauréal who introduced him to her cousin Madeleine Chapelle, his future wife.

This is a sketch for a larger pencil portrait dated 1813 in a private collection (Naef, 102).

21 Caroline Murat, Queen of Naples (1782–1839) 1814
Pencil: 43 x 50 (irregular)
Signed: *Ing.*
867.341; M. 228; Ternois, No. 145; Naef, *Bildnis*, No. 116

Joachim Murat (1767-1815), Marshal of France, married Caroline Bonaparte, Napoleon's youngest sister, in 1800 and was installed as King of Naples by Napoleon in 1808. Ingres was called to Naples in 1814 where he painted several pictures for the royal family, most of which were destroyed after Murat's fall and execution in 1815. However, several portrait drawings of members of the royal family survive, of which this one is the most famous. It appears to have been cut down from a larger drawing; the irregular edges cut through the pencil lines. This is Ingres' ideal of feminine beauty rather than a realistic portrait; the sitter's individual characterization is more apparent in a full length drawing in the Murat collection, Paris (Naef, 117).

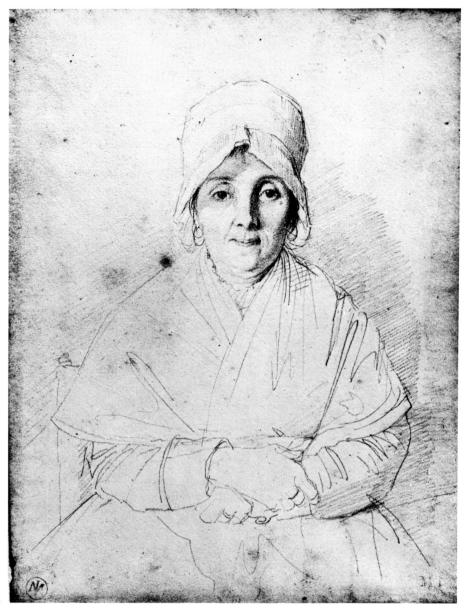

22

**22 Ingres' Mother, née Anne Moulet
(1758-1817)** *c.* 1815
Pencil: 197 x 157
867.276; M. 69; Ternois, No. 82; Naef,
Bildnis, No. 143

Ingres' mother visited her son in Rome soon
after being widowed in 1814. This drawing,
dating from about 1815, shows her at the age
of about 57. For an earlier portrait see
No. 17.

23 Louis Lazarini (b. 1798) *c.* 1820
Pencil: 135 x 85
Inscribed: *Louis Lazarini*
867.293; M. 556; Ternois, No. 98; Naef,
Bildnis, No. 249

The sitter was formerly identified as the
doctor Lazzarini whose family Ingres
portrayed in a group portrait in the Louvre
(Naef, 264) but Naef demonstrated that
these two are not identical. Indeed, the
painter Louis Lazarini was no relation of the
physician Cosimo Lazzerini in the Louvre
drawing. Louis Lazarini lived in Rome from
1817-1821.

24 An Italian Woman
Pencil: 230 x 186
867.415; London, No. 17; Ternois, No. 213

This drawing of an unidentified sitter is
usually placed in Ingres' first stay in Italy,
1806-24.

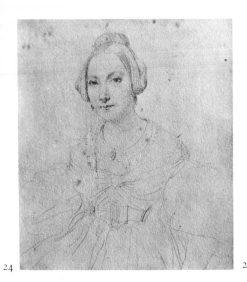

24

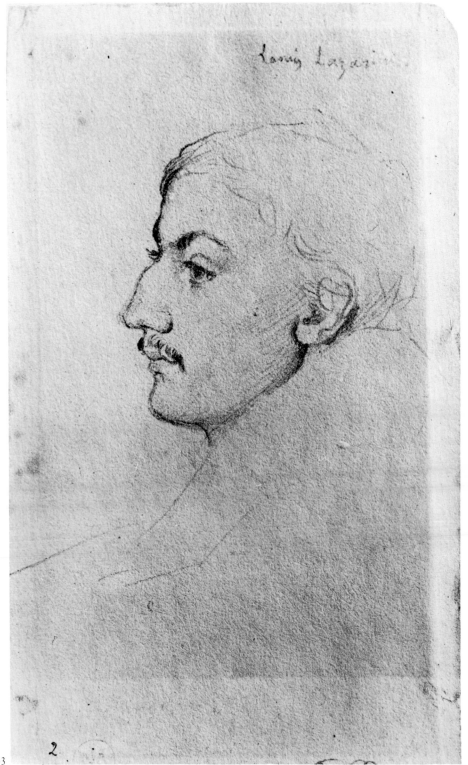

23

Portraits of English sitters

In 1814 the French government in Rome collapsed, Papal rule was restored and the French officials returned home. Early in the following year King Joachim Murat (see no. 21) was forced to abandon Naples. With these changes, Ingres was deprived of nearly all his patrons and by his own admission his financial plight became serious.

After Waterloo, however, the Grand Tour, which had been interrupted by a long period of war, was rapidly revived and brought a considerable influx of English visitors to Rome. It was among these that Ingres found sufficient sitters to tide him over a difficult time. During the years 1815-17 he received commissions for 33 portrait drawings of English and Scottish sitters and 28 drawings have survived.

Although they are now recognized as some of his most acute characterizations and most delicate drawings, these portraits were not rated very highly by Ingres himself and when he was commissioned by the Comte de Blacas, French Ambassador in Rome, to decorate the Church of S. Trinità dei Monti in 1817, this series of drawings came to an abrupt end.

* 25 **Lady William Cavendish-Bentinck** 1815
Pencil: 409 x 287
Signed and dated: *Ingres Del./rome 1815*
Ford, p. 7; Paris, No. 87; Naef, *Bildnis*, No. 159

Née Lady Mary Andeson, the sitter was the daughter of the first Earl of Gosford. Her husband was Governor of Madras and then minister to the King of Sicily. From 1814-1827 he was in Rome in no official capacity, after which he was sent to India as Governor of Bengal and finally became the first Governor General in 1833.
 The formal setting of this drawing – the accessories of table, chair and curtain – is reminiscent of Ingres' portrait of Napoleon as first Consul (Lièg Museum, W.14). A drawing of the following year in the Metropolitan Museum shows the sitter more informally posed (Naef, 174) while in a third drawing she is portrayed together with her husband (Musée Bonnat, Bayonne, Naef 175).

Amsterdam, Rijksmuseum,
Rijksprentenkabinet

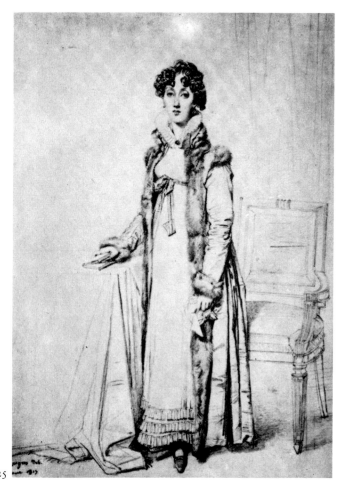

25

26 **Mrs John Mackie, née Dorothea Sophia Deschamps (1755-1819) with the Villa Medici in the background** 1816
Pencil: 209 x 164
Signed and dated: *Ingres a /Rome 1816*
Paris, No. 90; Naef, *Bildnis*, No. 169

John Mackie (1748-1831), of Scottish origin, was a successful physician in Southampton until 1814, when he began a ten years' tour of the Continent. His wife Dorothea was the daughter of a Frenchman who had become a Protestant clergyman in Germany and settled in London in 1753. She translated the *Letters of Madame de Sevigné* (1802) into English.

The date of the portrait is fixed by an entry in the diary of Mrs Mackie's daughter, Anna Sophia: '18 April 1816: Dear Mama's likeness by Ingre (sic) finished and very good. I am delighted to have it'.

The drawing remained in the possession of the sitter's family until it was given to the Victoria and Albert Museum by Winifred M. Giles, a great-great niece of Dr Mackie, in 1946.

Victoria and Albert Museum (E. 230-1946)

27 **Thomas Philip Robinson, 3rd Baron Grantham, later 2nd Earl de Grey (1781-1859), with the dome of St Peter's in the background** 1816
Pencil: 398 x 261
Signed and dated: *Ingres Del. Rome /1816*
Ford, p. 9; Naef, *Bildnis*, No. 177

This, and the portrait of Lady Cavendish Bentinck (no. 25) are the largest of Ingres' portrait drawings of English sitters and presumably also the most expensive. The sitter is shown as a fashionable young man of great elegance. He later became first Sea Lord in Peel's Cabinet of 1835 and subsequently Lord Lieutenant of Ireland in 1841-44. The drawing has remained in the sitter's family until the present day.

R.E.J. Compton Esq

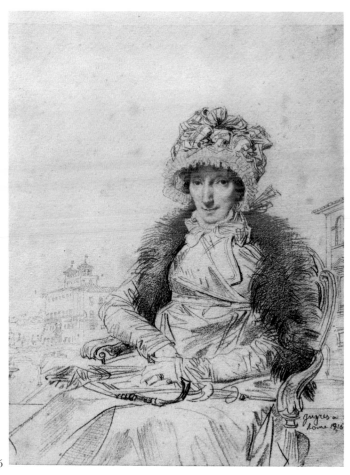

26

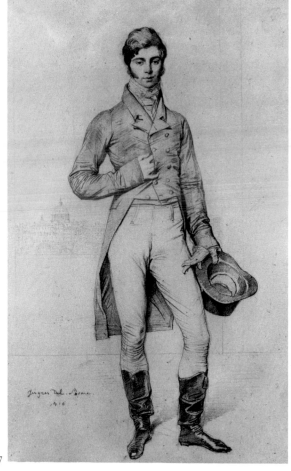

27

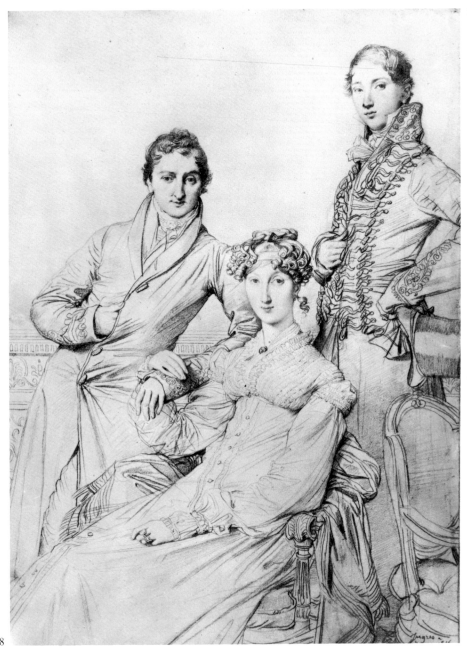

28

28 Joseph Woodhead (left) **and his wife Harriet Comber, and her brother Henry Comber** 1816
Pencil: 304 x 224
Signed and dated: *Ingres a/rome 1816*
Ford, p. 7; Naef, *Bildnis*, No. 180

Joseph Woodhead (1774-1866) was a Navy Agent who married Harriet Comber (1793-1872) in 1815. They travelled on their honeymoon with Mrs Woodhead's brother, Henry Comber (1798-1883), who later became Rector of Oswaldkirk, York and then Vicar of Creech St Michael, Somerset.
 This is another of Ingres' rare group portraits. It remained in the sitter's family until it was sold in 1947.

Fitzwilliam Museum, Cambridge

29 Sir John Hay, later 6th Baronet Hay (1788-1838) and his sister Mary, later Mrs George Forbes (1790-1877) 1816
Pencil: 292 x 222
Signed and dated: *Ingres Del./a Roma/ 1816*
Ford, p. 8; Paris, No. 91; Naef, *Bildnis*, No. 187

The sitters have the appearance of an engaged or married couple, so that when the lady was identified as Sir John Hay's sister Mary, an element of doubt remained. This was removed when family tradition revealed the full story of the drawing's origin.
 Mary and George Forbes were in Rome as an engaged couple in 1816 and commissioned Ingres to do a drawing. Unfortunately George Forbes had to leave Rome at the time fixed for the sitting which the artist refused to change. Sir John Hay, Mary's brother, was called in as a substitute but the artist also refused to alter the grouping of the portrait. 'Thus we have a double portrait of brother and sister looking ... much more like an engaged couple' (Elizabeth Senior in *Burlington Magazine*, Sept. 1939, p. 128; Naef, *Bildnis*, II, Chapter 66).

Trustees of the British Museum

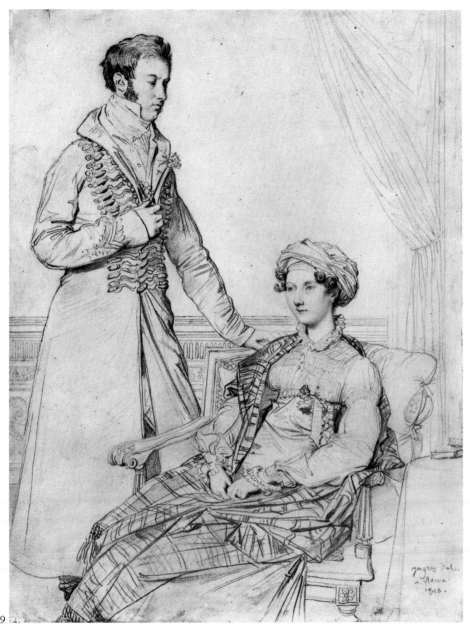

29

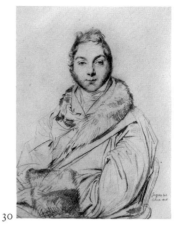

30

30 Alexander Baillie (**1777–1855**) 1816
Pencil: 215 x 165
Signed and dated: *Ingres. Del. /rome 1816*
Naef, *Bildnis*, No. 186

Originally called 'Alexandre Boyer' by
Lapauze, the sitter was identified as
Alexander Baillie by Hans Naef on the
grounds of his resemblance to a bust of
Baillie made by Thorvaldson in Rome in
1816 (*Burlington Magazine*, Dec. 1956, p. 435).

Alexander Baillie, member of a
distinguished Scottish family, was the son
of James Baillie, M.P. for Ealing Grove,
Middlesex. He appears as a boy of about
seven in Gainsborough's group portrait of
c. 1784 of the Baillie family in the Tate
Gallery. On a voyage to Jamaica he met a
young Norwegian merchant Jorgen
Cappelen Knudtzon (1784–1854) who was
to become his life's companion. The pair
travelled frequently to Rome and to Naples,
where they acquired a house and a
considerable collection of both
contemporary art and classical sculpture.
Apart from his patronage of artists, Baillie's
fame rests on his friendship with Byron:

"Baillie (commonly called Long Baillie, a
very clever man but, odd) complained in
riding to our friend Scrope B. Davies 'that
he had a *stitch* at his side'. 'I don't wonder
at it' (said Scrope) 'for you ride *like a tailor*'.
Whoever had seen B. on horseback, with
his very tall figure on a small nag, would
not deny the justice of the repartee" (*The
Works of Lord Byron, Letters and Journals*,
ed. R.E. Prothero, V, 1901, p. 419).

Mrs M. Feilchenfeldt, Zurich

Later Portraits
1830-60

With the growing reputation and increasing number of commissions
enjoyed by Ingres after his return to Paris in 1824, he was never again
dependent upon the production of portrait drawings to earn a living.
Nevertheless he continued to produce finished drawings of members of his
family and friends, but the majority of portraits in this section are preparatory
sketches for oil paintings, which were in his studio at his death and which he
bequeathed to the Montauban Museum.

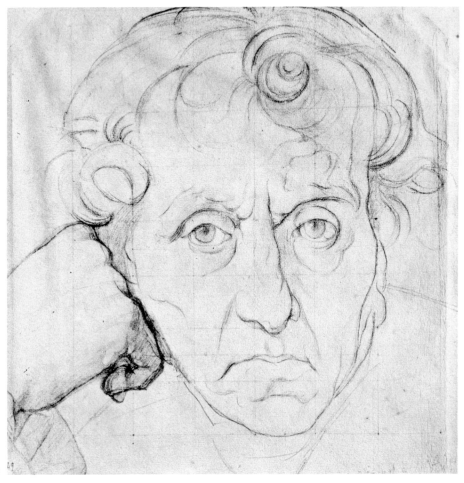

31

31 **Salvador Cherubini (1760-1842)** *c.* 1833
Black chalk and pencil: 258 x 254 squared
Inscribed: *Original à M. . . .*
867.223; M. 1327; Ternois, No. 34

The composer Cherubini, born in Florence
in 1760, spent much of his life in France,
where he became superintendent of the
King's music in 1816 and director of the
Conservatoire in 1822. He was a personal
friend of the painter and in return for his
portrait he composed his *Ode à Ingres*.

The portrait was begun in Paris in 1833,
continued in Rome in 1839 and completed
in 1842. The final composition, showing
the composer crowned by the Muse of
lyric poetry, is in the Louvre (W. 236);
there is a version without the Muse in the
Cincinnati Museum (W. 235). The position
of the hand in this drawing differs from
that in the oil painting.

32 Madame Ingres, née Madeleine Chapelle (1782–1849) 1835
Pencil: 300 x 216
Signed: *Ingres fec*; Inscribed in the sitters' hand *Mme Ingres à Mlle Maille Mars 1835*
867.278: Ternois, No. 84; Paris, No. 172

Shortly after Ingres returned to Rome to take up the directorship of the French Academy in 1835 he drew a self portrait which he dedicated to his students (Louvre), and this drawing of his wife dates from the same time. It was given by Mme Ingres to Caroline Maille, later Mme Gonse, a pupil of Ingres, and it remained in her possession until her death in 1901.

33 Pauline Gilibert, later Mme Montet (born *c.* **1830)** 1842
Pencil: 188 x 196
867.254; M. 3807; Ternois, No. 62

Pauline was the daughter of Jean-François Gilibert, Ingres' oldest and most faithful friend, and she herself learnt to paint in the master's style. This drawing has been dated March–May 1842 when Gilibert and Pauline visited Paris from Montauban.

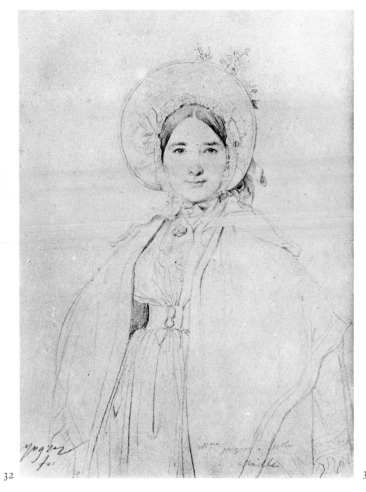

32

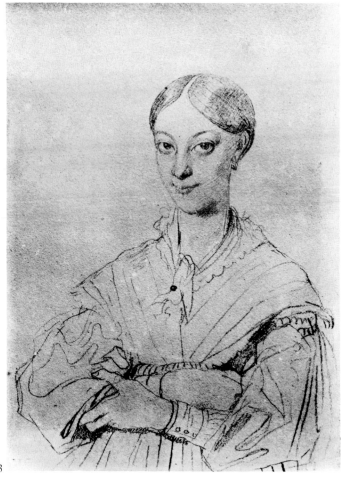

33

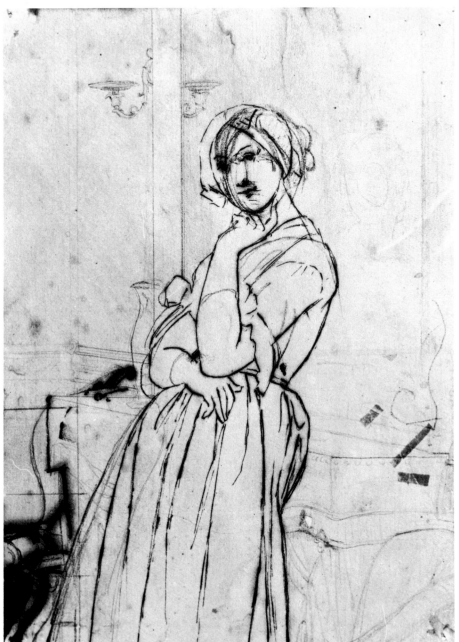

34

34 **The Comtesse d'Haussonville
née Louise de Broglie (1818–1882)**
c. 1845
Pencil and pen and ink: 234 x 172
867.259; M. 1828; Ternois, No. 66

Louise de Broglie married Vicomte
Othenin d'Haussonville, deputy, senator,
historian and member of the Académie
française, in 1839. She was the grand
daughter of Mme de Staël and herself
published an historical novel, *Robert Emmet*
(1858) and two biographies, *Marguerite de
Valois* (1870) and *Les dernières années de
Lord Byron* (1874).

Ingres accepted the commission to paint
her portrait in 1842. A drawing at
Montauban and an oil sketch (W. 238)
show her turning to the right, but in
subsequent drawing and in the final
composition (New York, Frick Museum,
W. 248, dated 1845) she is turning to the
left. Her attitude reminiscent of that of
Stratonice (No. 60), is based on Ingres'
study of classical sculpture.

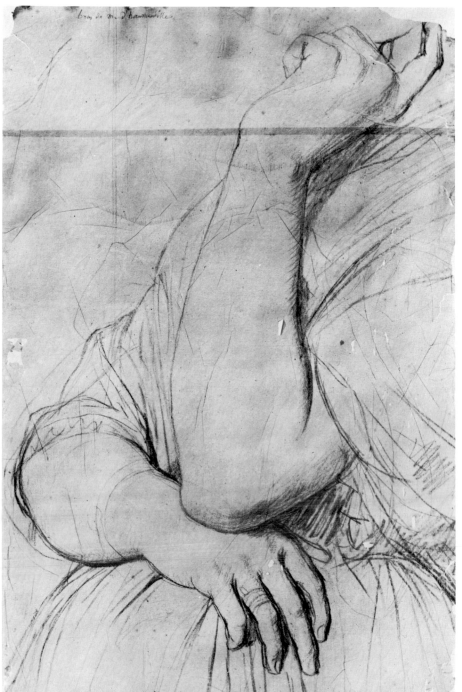

35 **The arms of the Comtesse d'Haussonville**
Black chalk: 470 x 309
Inscribed: *bras de Me d'haussonville*
867.262; M. 1829; Ternois, No. 69; Paris, No. 236

36 **Reflection of the head of the Comtesse d'Haussonville**
Black chalk and stump heightened with white: 435 x 328
Signed: *Ing.* Inscribed *Mme. la C. d'Haussonville*
867.263; M. 1880; Ternois, No. 70; Paris, No. 238.

35

36

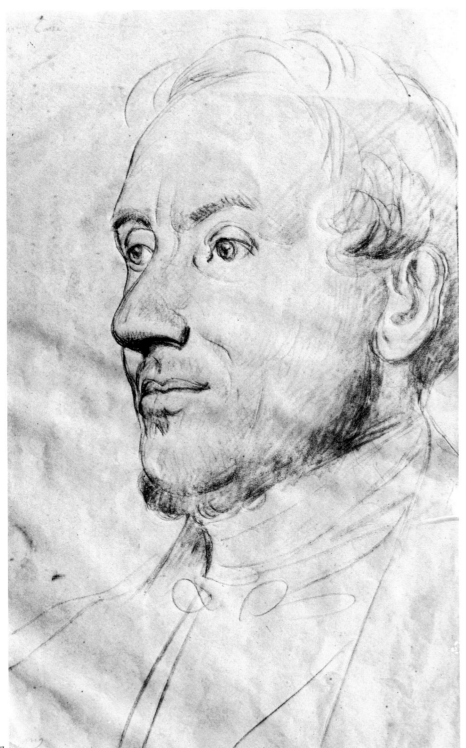

37 Edmond Cavé (1794-1852) 1844
Black chalk: 362 x 228
Signed: *Ing.* Inscribed: *M. Cavé*
867.209; M. 1291; Ternois, No. 20.

Edmond Cavé, a music hall author, was
director of Fine Arts at the Ministry of the
Interior from 1839 until the Revolution of
1848. This is a sketch for the oil painting,
dated 1844, in the Metropolitan Museum,
New York (W. 246). The traces of hard
point on this drawing indicate that it may
have been used to transfer the outlines onto
the canvas.

38 Madame Ingres' Cat
Pen and ink: 80 x 84
867.281; M. 3766; Ternois, No. 86

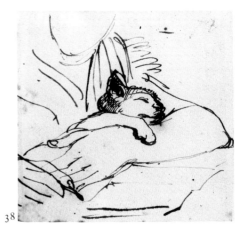

37

38

39 Project for the tomb of Lady Montague 1860

Pencil and water colour: 355 x 265

Signed and dated: J. INGRES IN^IT ET DEL^IT ET FECIT ROMA 1860 Inscribed on the cartouche: LADY JANE MONTAGUE OBIIT ANNO AETATIS XX ROMA

D. 54.4.1. Ternois, No. 135

Lady Jane Montague, daughter of the Duke of Manchester and niece of the Duchess of Bedford, died in Rome in 1815 at the age of twenty. Ingres designed a tomb for her in the style of Italian Renaissance monuments. The original drawing is in the National Gallery of Victoria, Melbourne (A.P. Oppé, in *Old Master Drawings*, Sept. 1926, p. 20, fig. 29) but this is without the full frame and the putti.

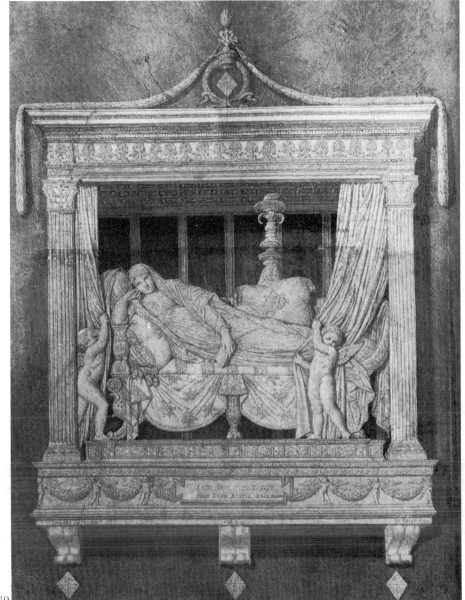

39

Studies for Paintings

Venus Anadyomene

The *Venus Anadyomene* (Venus rising from the sea) by Apelles – one of the most famous paintings of classical antiquity – inspired many poets and painters of the Renaissance, even though it no longer existed and was known only from descriptions. (For a discussion of the subject see Ronald Lightbown, *Botticelli*, 1978, I, p. 88).

Ingres conceived the idea for his picture in 1807, soon after his arrival in Rome. The oil painting, now in the Musée Condé, Chantilly (W. 257), was begun in 1808 but was not completed until 1848. The drawings belong to the earlier period.

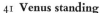

40 Venus standing
Pen and ink over pencil: 190 x 94
Inscribed: *Les Zephirs dans l'eau. Il lui attache un collier. Couronne de roses*
867.2302; M. 39; London, No. 1; Paris, No. 27

Venus riding on a shell, was blown to the shore by Zephyr as in the inscription, though the figures here look more like cupids. Her posture is very close to Botticelli's *Birth of Venus*, which Ingres may conceivably have seen at the Uffizi when he passed through Florence in 1806, but it is equally likely that he was directly inspired by classical paintings or reliefs.

41 Venus standing
Black chalk: 383 x 285
Squared, and inscribed: *Cadre ou encadre*(ment) *antique de cou*(leur) *Pompey hercu*(laneum)
867.2305; M. 42; London, No. 3; Paris, No. 28.

This is more strictly a composition of Venus Anadyomene in which Venus is shown drying her tresses after emerging from the sea (compare Titian's picture in Edinburgh) and this was the pose which Ingres used in the oil painting. This drawing shows the artist trying out several positions for the left arm; the lower posture was the one finally adopted.

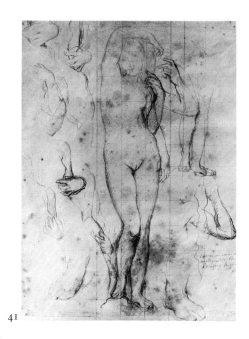

41

40

Miscellaneous
early drawings

43 **Standing female nude**
Pencil: 240 x 96
Signed: *Ing.*
867.2985; M. 3270: London, No. 11; Paris,
No. 65

This drawing dates from Ingres' first stay
in Rome, 1806-21, but neither the precise
date nor the projected painting has been
determined.

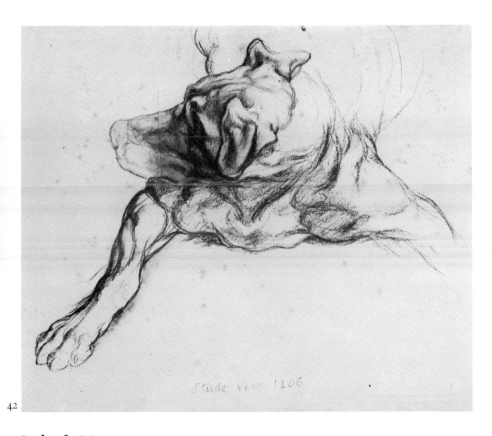

42

43

42 **Study of a Dog**
Black chalk and stump: 192 x 227
Inscribed in a later hand: *Etude vers 1806*
867.3127

35

Virgil reading the Aeneid

Virgil is shown reading from the *Aeneid* before Augustus, Livia and Octavia, who are deeply moved by the account of Aeneas meeting Marcellus in the Underworld (Bk VI, 860-86). The original painting, now in the Toulouse Museum (W. 83), was commissioned in 1812 by General Miollis for the Villa Aldobrandini. It demonstrates Ingres' debt to David, whose pupil he was in Paris from 1797. The picture was bought back by Ingres after 1832 and was subsequently enlarged and altered under his direction.

44 **General composition**
Black chalk and stump: 261 x 213
Signed: *Ingres*, inscribed: *J'ai fait cette maquette uniquement pour la conduite de l'effet et la juste valeur des objets. Je recommande à vos bons soins le légèreté, en général, des objets blancs, comme le candélabre et draperies . . .*
867.2453: M. 912; London, No. 7

Such detailed drawings of complete compositions are rare in the artist's work. This one was made by Ingres in preparation for Pradier's engraving of 1832. As the inscription shows, its main purpose was to indicate the effects of light for the engraver. A similar drawing in the Louvre, also made for the engraver, is dated 1830. The statue of Marcellus, which does not appear in the original painting, was derived from engravings of classical sculptures (see A. Mongan, in *Journal of the Warburg and Courtauld Institutes*, X 1947, p. 9).

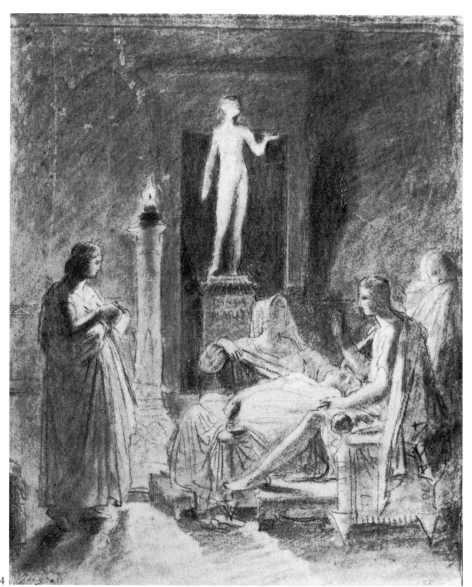

44

Angelica saved by Ruggiero

According to Ariosto's *Orlando Furioso* (1532, canto X, stanza 92), Angelica was exposed naked on the Isola del Pianto to be the prey of an Orc, but was saved by Ruggiero who was passing on a Hippogriff (half eagle, half horse). The story, like Ingres' composition, is related to the myth of Perseus and Andromeda and to the story of St. George and the Dragon.

Ingres' first painting of this subject is a large canvas in the Louvre, wider than its height, dated 1819. Although it aroused adverse criticism when it was shown at the Salon in that year, it was bought by Louis XVIII and hence became the first of Ingres' paintings to be acquired by the state. There are several later versions, including an oval dated 1841 at Montauban (W. 233) and a closely related one in the National Gallery (Martin Davies, *French School*, 1957, p. 118). These differ from the Louvre picture in shape and in the treatment of the Orc, but are otherwise very similar. There are twenty three preparatory drawings at Montauban dating from 1818-19, as well as others in the Musée Bonnat, Bayonne, the Fogg Art Museum, Cambridge, Mass. and elsewhere.

This is a key painting in Ingres' career and its wider importance has recently been discussed in Hugh Honour, *Romanticism* (1979).

45 Two nude studies for Angelica
Pencil: 254 x 161
867.2111; London, No. 18

Basically, the posture of the central figure is the final one. This is very clearly a life study; the figure is not stylized and elongated as it was to become in the finished painting.

45

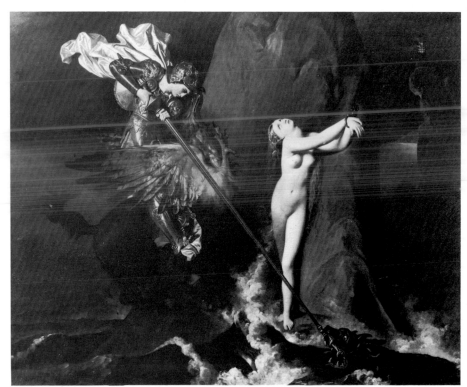

Angelica saved by Ruggiero

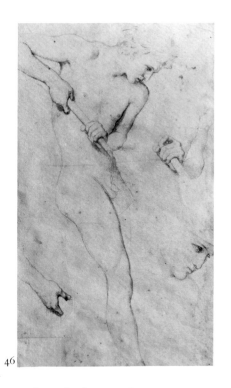

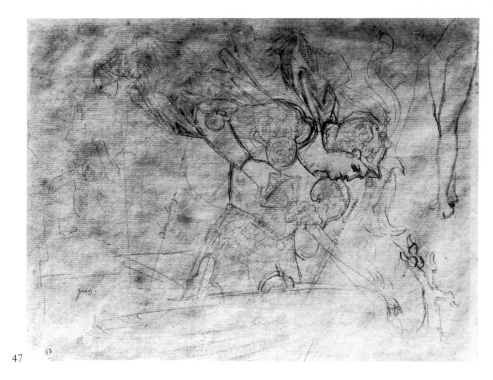

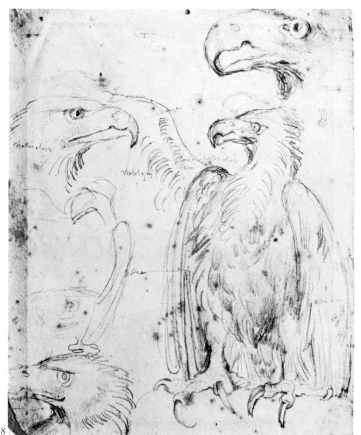

46 Nude study for Ruggiero
Pencil: 392 x 235
867.2107; M. 459; London, No. 19;
Paris, No. 109

This Raphaelesque drawing is an early
study for Ruggiero, before the addition of
the armour.

47 Study for Ruggiero in armour
Pencil: 210 x 280
Signed: *Ingres* inscribed with indications of
proportions
867.2109; M. 461

This study is very close to the final
composition. It has been suggested that the
armour is derived from that on the tomb of
Antonio da Rido, captain of the Papal
militia in the fifteenth century, in the
church of Santa Francesca Romana, which
Ingres is known to have copied (Paris,
p. 152).

48 Studies of an eagle, for the Hippogriff
Pencil: 199 x 165
Inscribed with colour notes
867.2125; M. 474, London, No. 20.

Christ handing the keys to St Peter (Matthew 16.19)

This picture, now in the Louvre (W. 132), was commissioned in 1817 for the church of S. Trinità dei Monti and was completed in 1820. The composition is derived from Raphael's tapestry cartoon (Victoria and Albert Museum), but Ingres' somewhat melodramatic interpretation became typical for French nineteenth century religious painting. There are about 40 preparatory drawings at Montauban, many of them for the drapery.

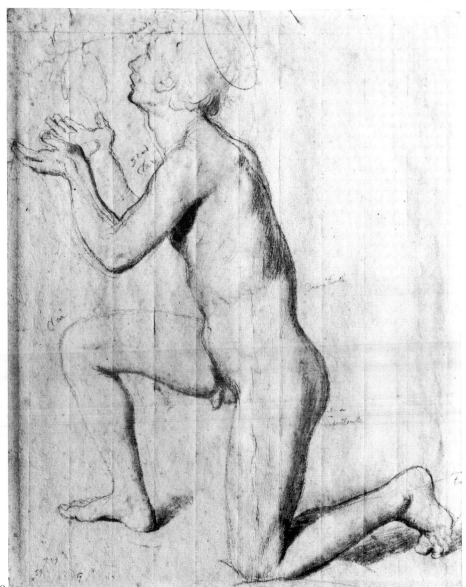

49

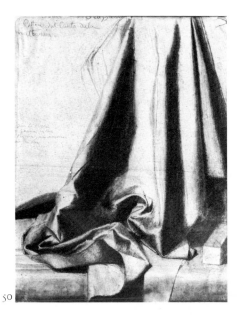

50

50 Drapery study: the hem resting on a table
Black chalk and stump: 516 x 386
Inscribed: *Pittore sul canto della mattonaia*
and below *Dans le Tableau de Jérémie ces tons de draperie jaune et marron font très bien*
867.1765; M. 518

51 Drapery study for a standing apostle
Black chalk and stump: 500 x 234
867.1782; M. 549

49 Nude study for St Peter
Black chalk and stump: 396 x 315
Signed: *Ing*, inscribed with colour notes.
867.1747; M. 512; London, No. 22.

This drawing demonstrates that, however traditional the composition, Ingres always began his own work with life studies.

The Apotheosis of Homer

As part of a comprehensive plan to decorate nine new rooms in the Louvre, the Comte de Forbin, director-general of Museums, commissioned Ingres to paint this subject for a ceiling in the Salle Clarac in 1826. It was installed in time for the opening by Charles X in November 1827. Subsequently a copy was put in its place and the original shown vertically.

Homer, enthroned in front of a temple, is crowned by Fame. At his feet are female personifications of the Iliad and the Odyssey; on each side are artists, writers, musicians and patrons of the arts.

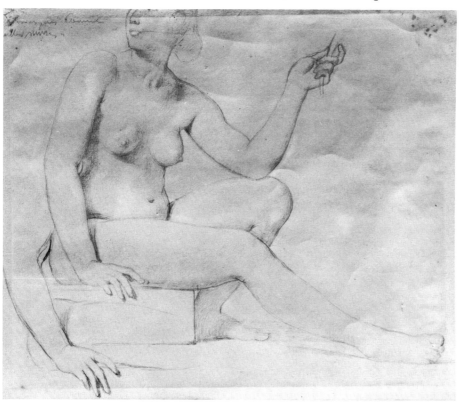

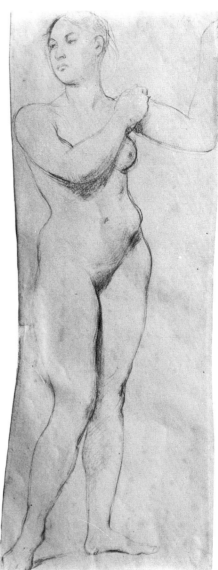

52 **Nude study for the Odyssey**
Black chalk: 262 x 320
867.904; M. 693; Paris, No. 146

The animated pose of this drawing contrasts with the immobile figure at Homer's feet in the final composition. There are also several studies of the figure, draped, at Montauban.

53 **Study for the allegory of the City of Rhodes**
Black chalk: 385 x 510
867.1068; M. 857; Paris, No. 149

In the voussoirs of the Salle Clarac, surrounding the Apotheosis of Homer, Ingres' pupils painted allegorical figures of seven cities disputing Homer's birth place, based on the master's design.

53

The Martyrdom of St Symphorian

St Symphorian was a youth martyred at Autun in about 160-79 for refusing to prostrate himself before an idol. The picture was commissioned for the Cathedral by the Bishop of Autun, who described in great detail the composition he had in mind. The moment depicted is when the young martyr was led out of the city to sacrifice at the temple or to be put to death. He turns towards his mother who, from the city wall above, encourages him to face death with equanimity. Ingres followed his instructions in detail and visited Autun in 1826 to study the remains of the Roman wall. He worked on the painting in 1827 but it was not completed until 1834. There are about 200 preparatory drawings at Montauban which are exceptional in Ingres' output for their study of movement and expression.

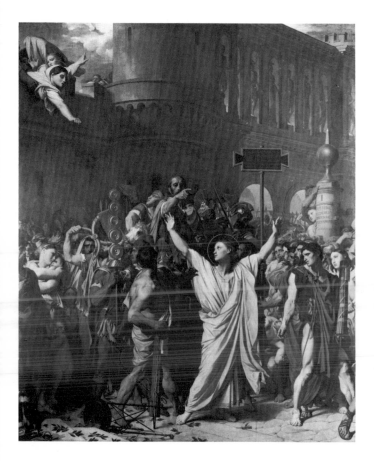

The Martyrdom of St Symphorian

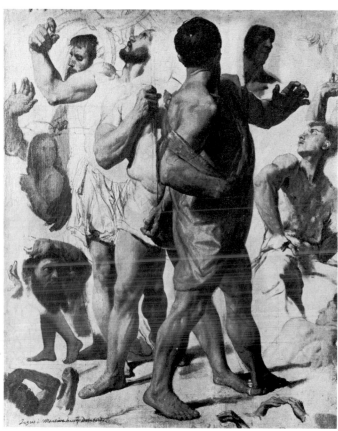

54 **The Lictor in the foreground and other studies**
Oil on canvas: 650 x 500
Inscribed: *Ingres à M. henry Delaborde*
49.1; W. 215; Paris, No. 162

As well as making countless drawings, Ingres carried out several oil studies for this composition, of which eleven are still extant.

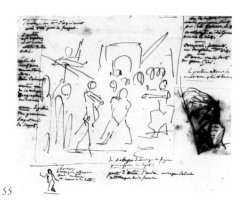

55

55 First idea for the composition
Pen and ink: 160 x 200
Inscribed with numerous notes: *Vu des pères et martyres et autres principaux Saints* etc.
867.1799; M. 948; London, No. 28

Ingres' working method was to sketch his first ideas for a composition in rapid pen drawings which are totally different from his better known life studies in pencil or chalk. (See R.C.E. Longa, *Ingres Inconnu*, 1942).
 Here the Saint is shown kneeling in the centre (in the painting he is standing); on the right the Proconsul delivers the sentence, on the left the executioner draws his sword.

56 Nude study for the Saint's mother
Pencil: 367 x 251
Inscribed with indications of lighting.
867.1887; M. 1038; London, No. 31; Paris, No. 164

She leans over a battlement; her left arm is shown in four different positions.

57 Nude study for the Saint's father
Black chalk: 290 x 162
Signed: *Ing*
867.1895; M. 1047; London, No. 32; Paris, No. 165

In the final composition he is hooded, standing on the wall behind the Saint's mother.

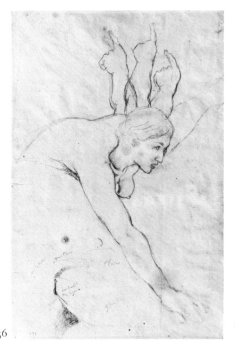

56

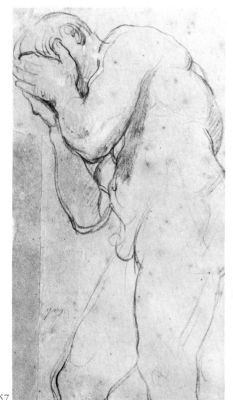

57

58

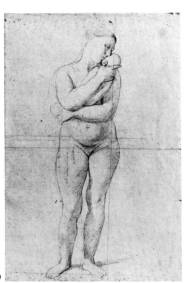

59

58 Nude study for the mounted Centurion
Black chalk: 505 x 354; several pieces of paper stuck onto sides of original sheet.
867.1832; M. 982; London, No. 34

Behind the centurion is a study for the second horseman.

59 Nude study for the Mother and Child
Black chalk: 517 x 345
867.1932; M. 1087; Paris, No. 168

Antiochus and Stratonice

The doctor Eristratus discovered the cause of the illness of Antiochus, son of King Seleucus, in his love for his mother-in-law, Stratonice. Ingres had produced a drawing of this subject as early as 1807 (Louvre), but the final painting, commissioned by the Duc d'Orleans in 1834 and begun in 1836, was not finished until 1840 (Musée Condé, Chantilly, W. 232).

60 **Study for Stratonice**
Pencil: 223 x 131
Inscribed: *Très clair*
867.2198; M. 1227; London, No. 45

The pose of Stratonice has been compared with that of Penelope in a Roman painting from Pompeii (Paris 184).

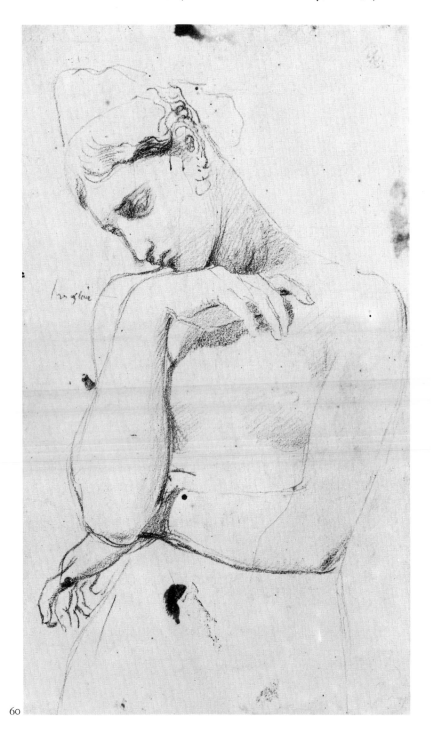

60

The Odalisque with a Slave

Although he never travelled to Turkey or the Middle East, Ingres painted such idealized, submissive women of the harem (odalisques) throughout his career. This picture, commissioned by M. Marcotte d'Argenteuil, was painted in Rome in 1839. It is now in the Fogg Art Museum, Cambridge, Mass., and there is a replica in the Walters Art Gallery, Baltimore (W. 228, 237).

61 **Original sketch for the composition**
Pen and ink: 156 x 185
Signed: *Ing*. Inscribed with proposed titles:
Le Repos de la Sultane, Une Sultane et ses femmes, le Sommeil, Italienne faisant la Sièste, la Siesta une guittarre
867.2029; M. 1254; London, No. 50;
Paris No. 177

This is the first project for the composition. In the finished picture, the two figures, on the left were omitted but the positions of the odalisque and slave remained as they are here.

61

62 **Nude study of a reclining woman**
Pencil: 152 x 273
Signed: *Ing*; inscribed: *Mariuccia blonde belle via Margutta 106*
867.2030; M. 1255; London, No. 51;
Paris, No. 176

The woman's right arm is shown twice, once resting on her body as in the *Dormeuse de Naples* of 1808 (original lost; version in Victoria and Albert Museum) and once raised behind her head as in the *Odalisque with a slave* of 1839. It may, therefore, be linked with either of the two compositions, possibly it is an idea for the later one, harking back to the earlier posture.

The inscription gives the name and address of the model and indicates that the drawing was made in Rome.

63 **Nude study for the slave playing the guitar**
Black chalk: 514 x 373
867.2031; M. 1256; London, No. 52;
Paris No. 181

This is the definitive posture of the slave as it appears in the finished picture; there is a similar drawing in the British Museum (Paris, No. 180).

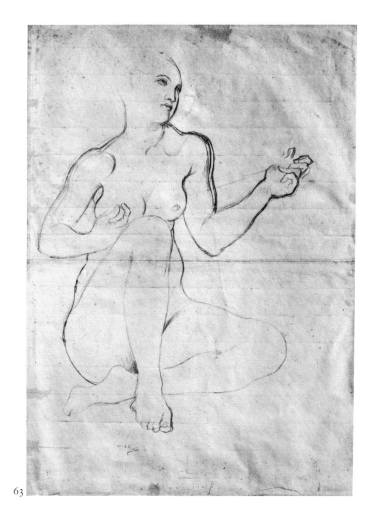
63

The Virgin with the Host

In a composition reminiscent of Raphael's *Virgin with the candlesticks* (Walter's Art Gallery, Baltimore), the Virgin is surrounded by St. Nicholas and St. Alexander Nevsky, the patrons of the Czarevitch, later Alexander II, who commissioned this picture in 1839. It was completed in 1841 and is now in the Pushkin Museum, Moscow (W. 234).

64 **Nude Study for St Alexander Nevsky**
Black chalk: 392 x 255
Signed: *Ing.* inscribed with notes on the lighting.
867.2365; M. 1303

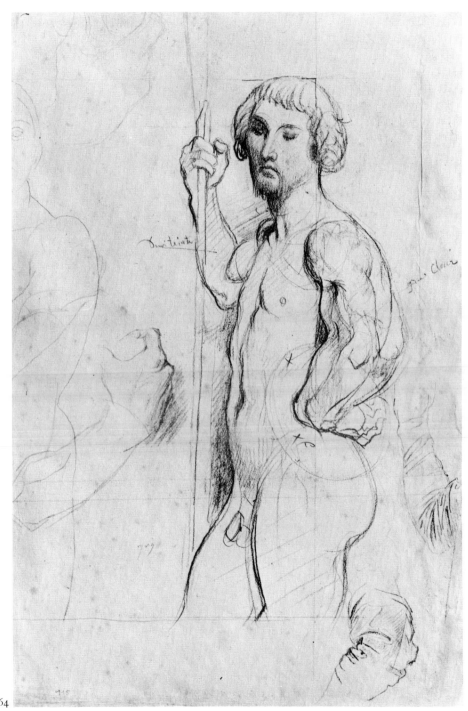

64

The Golden Age

In 1839, while he was still in Rome, Ingres received a commission from the Duc de Luynes to paint a mural decoration for his château at Dampierre, near Paris. As his subjects he chose the *Golden Age* for one wall and the *Iron Age* for the other. Having prepared his designs and made the decision to paint in oil rather than tempera, he began work at Dampierre in 1843. Ingres abandoned the project after the death of his wife in 1849, leaving the *Golden Age* unfinished and the *Iron Age* barely sketched in, but it remains one of his major projects and there are no less than 400 drawings for it at Montauban. There is a reduced replica dated 1862 in the Fogg Art Museum (W. 301).

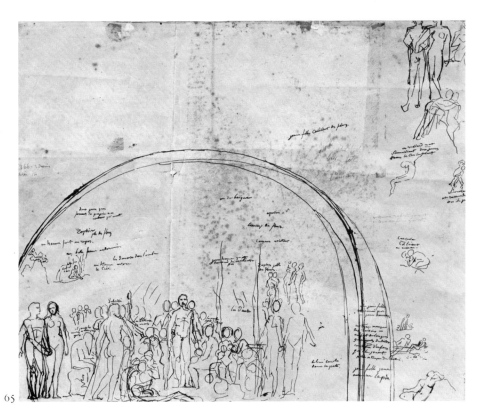

65

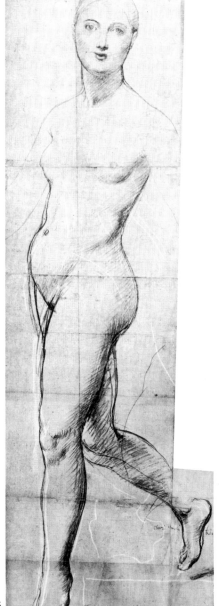

66

65 **General sketch of the composition**
Pen and ink: 390 x 483
Inscribed: *Jeunes filles cueillant des fleurs. Un vieillard mort Zephire jette des fleurs. On se baigne* etc.
867.422; M. 1364; London, No. 53; Paris, No. 218

The semi-circular shape is derived from Raphael's Vatican frescoes, but the conception of dancing figures and amorous couples in an Arcadian landscape is inspired by Watteau, from whose work Ingres made numerous copies at this date.

66 **Dancing woman**
Black chalk heightened with white: 1230 x 448
Squared for transfer, inscribed *clair* etc.
867.505. Paris, No. 220

A study for the central figure in the group of dancers. The exceptional size suggests that this is a cartoon, probably drawn in the studio in Paris and used for transfer at Dampierre.

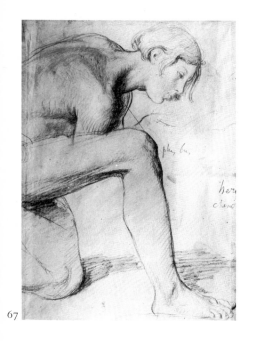

67

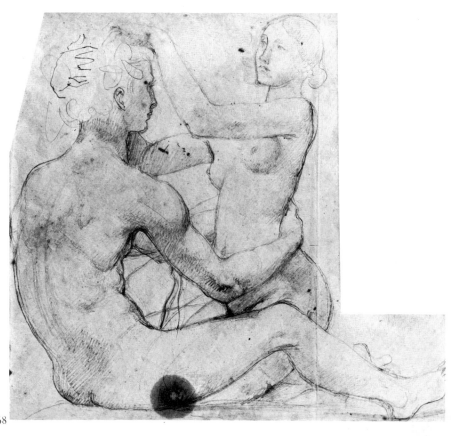

68

67 **Young man kneeling at the feet of Astraea**
Black chalk: 276 x 200
Inscribed: *Plus bas* etc.
867.559, M. 1535; London, No. 55;
Paris, No. 225

68 **Girl crowning a youth**
Pencil: 234 x 255
867.684; M. 1389

In the replica of 1862 it is clear that the girl is crowning the youth with a floral wreath. This is a drawing which, particularly in its firm modelling, shows Degas's debt to the teaching of Ingres.

69 **Copy of the head of Raphael's**
Madonna della Sedia
Pencil and stump on tracing paper: 191 x 246
867.825; M. 1625

This drawing has been hypothetically linked with the woman in the foreground of the painting with her arms round the man, but it is included in the exhibition to demonstrate Ingres' continued veneration of Raphael.

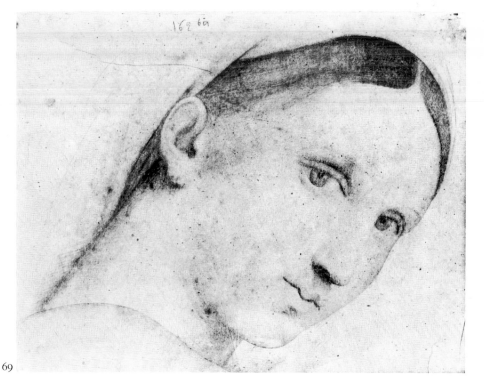

69

The Turkish Bath

The first version of this painting was completed in 1852; it was reworked and sold to Prince Napoleon in 1859. Shortly afterwards it was returned to the artist because, it is said, Princess Clotilde was shocked by the many nudes. Ingres then made further alterations, which included the change from rectangular to circular shape, and finally sold the picture to Khalil Bey, Turkish ambassador in Paris, in 1862.

This is Ingres' final statement on a subject which he had worked on all his life and it contains many quotations from his earlier paintings, such as the *Bather of Valpinçon* (1808; Louvre). His interest in the subject had been fired by reading Lady Mary Wortley Montague's description of the women's baths at Adrianople and he possessed a number of engravings from travel books of the Near East. There has recently been an exhibition devoted to this painting at the Louvre: *Le Bain Turc d'Ingres*, 1971.

70 **Nude woman sitting on the ground**
Oil on paper: 250 x 260
867.1220; M. 2036; W. 313; London,
No. 68; Paris, No. 261

The right arm is shown twice; resting beside the body and raised above the head. For this, as for other figures in the composition, Ingres was inspired by engravings in *Cent estampes qui représentent différentes nations du Levant*, Paris 1714. In the finished painting he retained the raised arm posture, but, as in this study, the arm does not fit well onto the shoulder.

71 **Nude woman seated**
Pencil: 243 x 143
867.1206; M. 2022

This is the woman seated at the edge of the bath on the left. The figure was added to the composition during the modifications made in 1860-62, and this provides the date of the drawings. There is another such study at Montauban (Paris, No. 264).

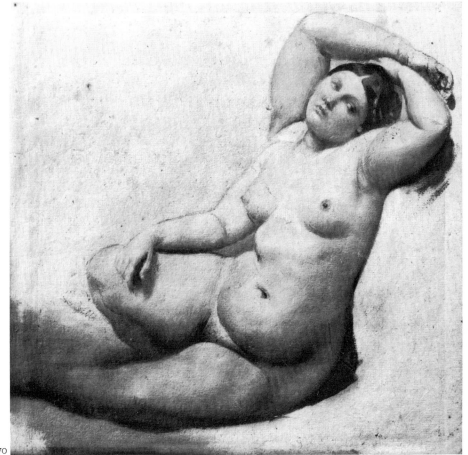

70